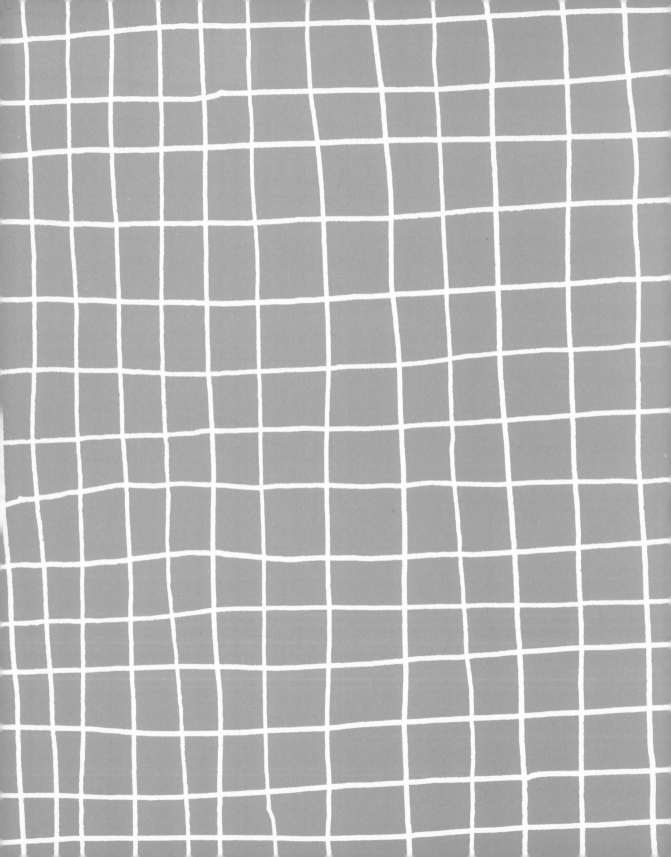

420 THINGS TO DRAW WHILE HIGH

CHRONICLE BOOKS

SAN FRANCISCO

ISBN 978-1-4521-7690-1

Manufactured in China

Design by Neil Egan
Cover illustration by Riza Cruz

10 9 8 7 6 5 4 3 2 1

Chronicle Books LLC
680 Second Street
San Francisco, California 94107
www.chroniclebooks.com

a cat named Ganja

a lazy afternoon

a ripple

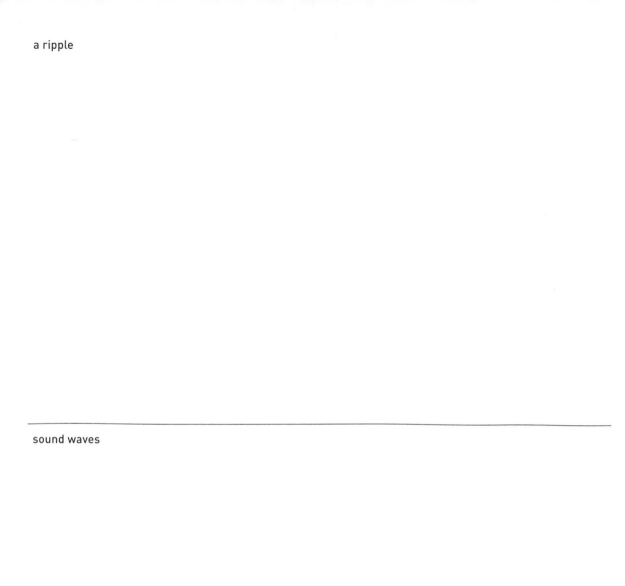

sound waves

a mind meld

a mushroom house

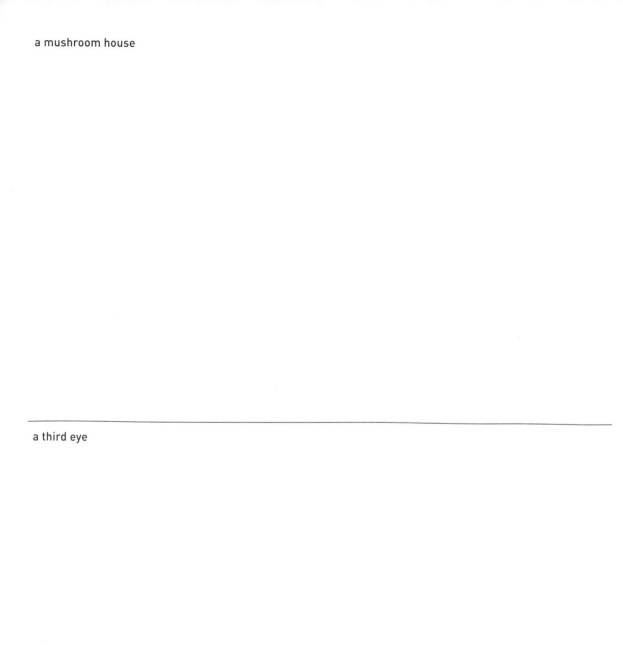

a third eye

a wizard's pipe

smoke on the water

a misty mountaintop

an alien in a hammock

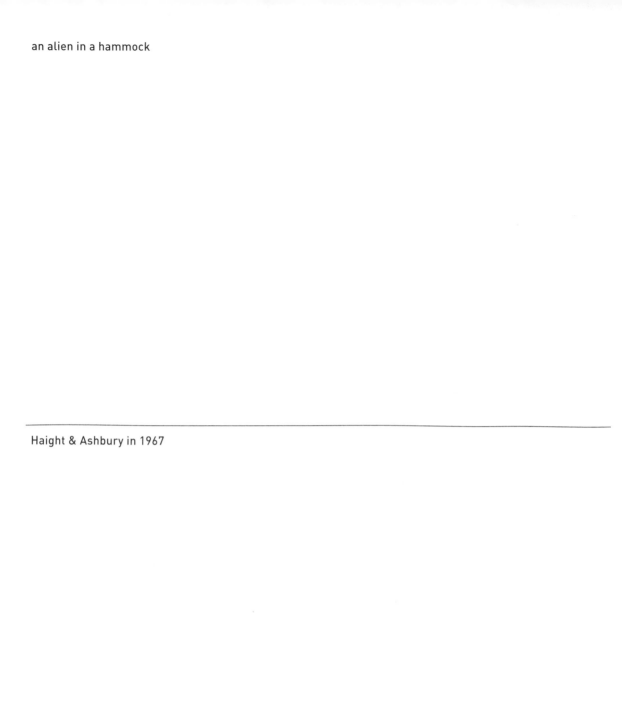

Haight & Ashbury in 1967

two giraffes riding a rainbow

a spliff rocket

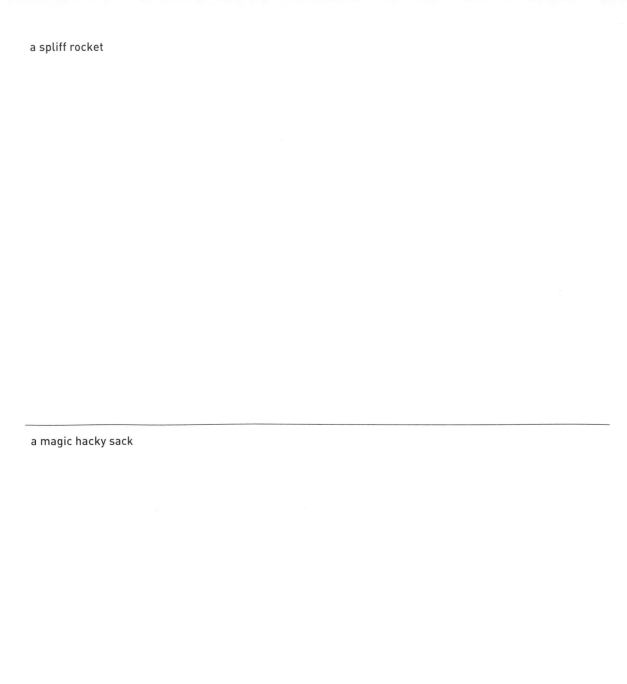

a magic hacky sack

world peace

a Bob Marley tattoo

the astral plane

a past life

fuzzy feelings

what you were just thinking

an apple pipe

fireworks on April 20th

a magical brownie sundae

Willie Nelson at the White House

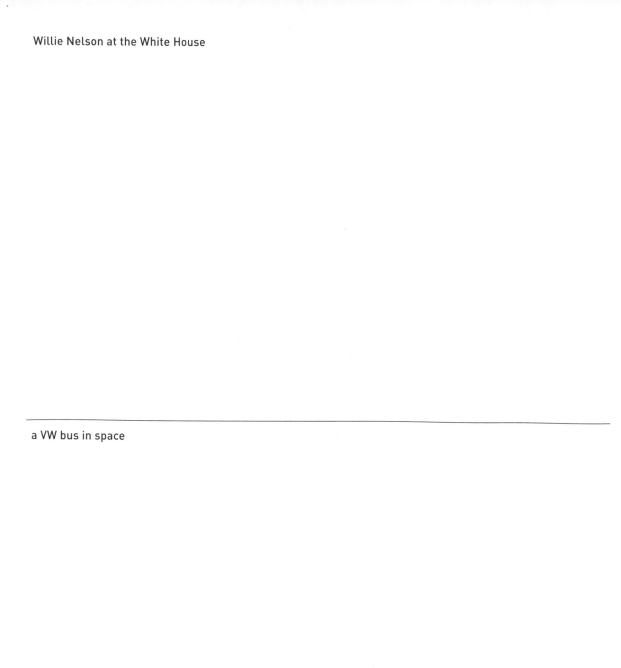

a VW bus in space

the center of the universe

a drum circle on Mars

what you just forgot

a half-baked plan

a dolphin who can read your mind

crop circles

a gummy bear picnic

a glass of water

coral reefer

a dreaming cat

an ice cream cone

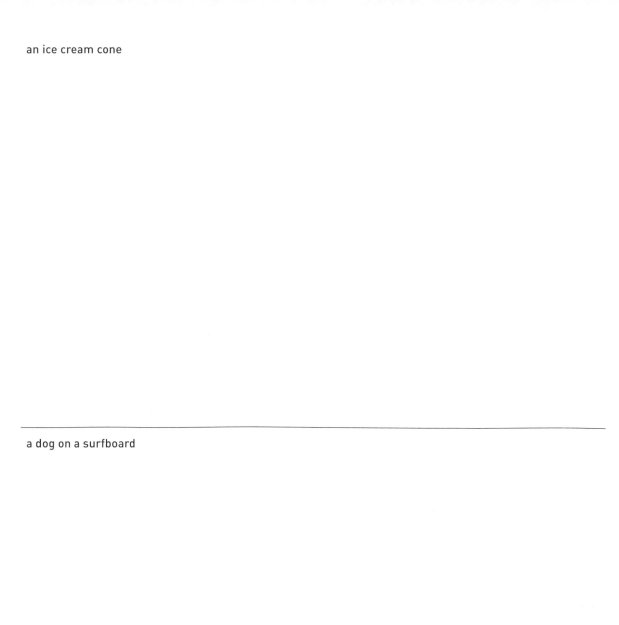

a dog on a surfboard

a maze

your hand drawing your hand

grass between your toes

a cheese puff

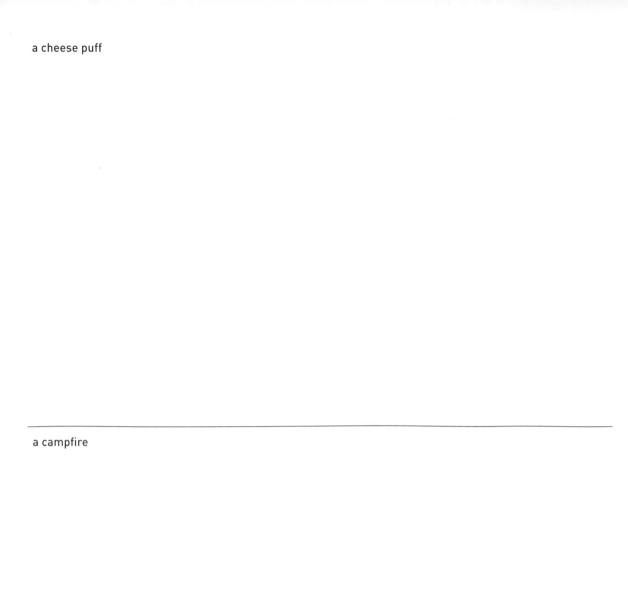

a campfire

high tops

Big Ben striking 4:20 p.m.

your ceiling

so many dots

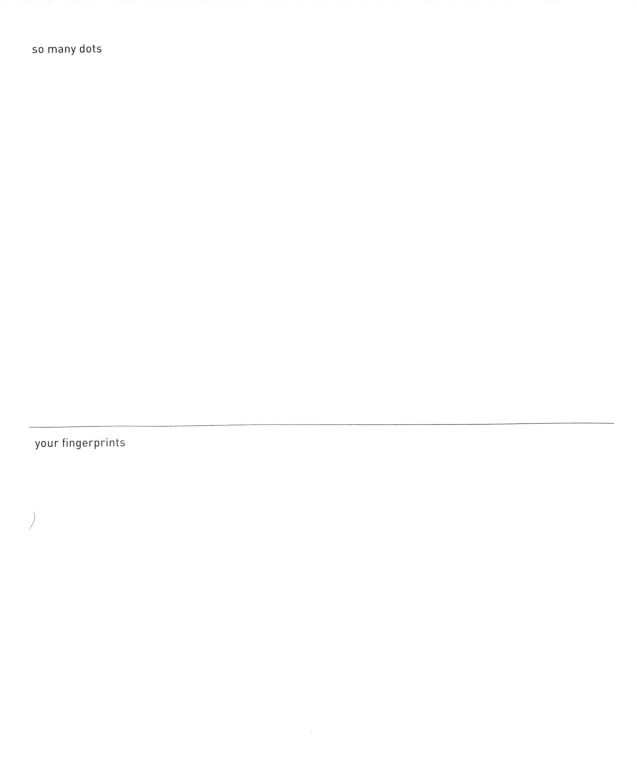

your fingerprints

a sun shower

a dessert oasis

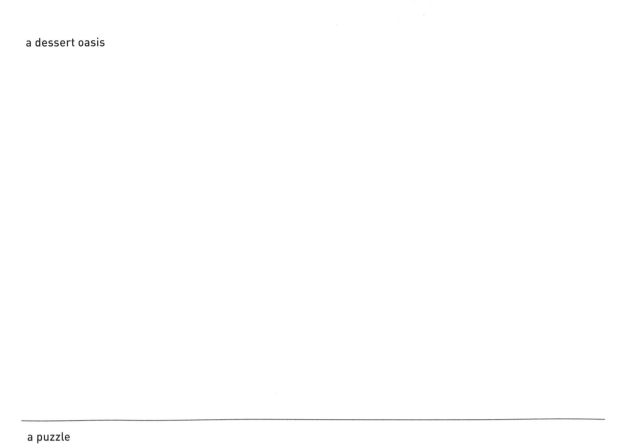

a puzzle

a friendship bracelet

a massage

positive energy

flower buds

a bee's knees

Bob Ross

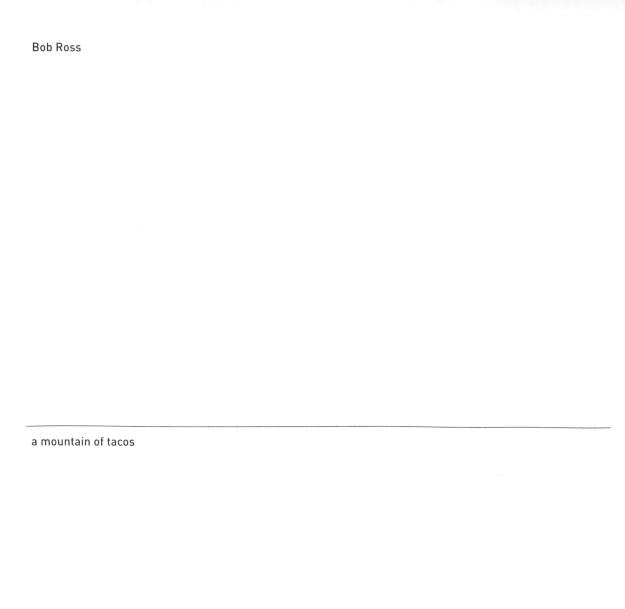

a mountain of tacos

a sloth in a leotard

the world's comfiest beanbag chair

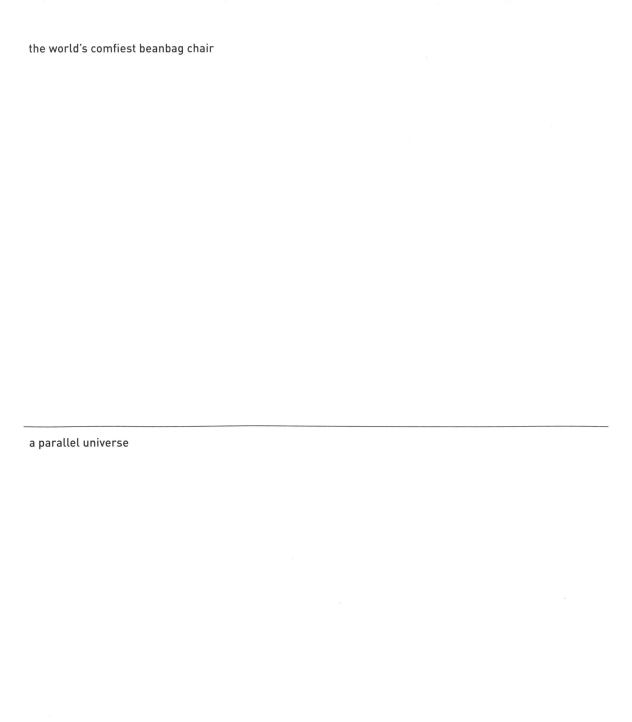

a parallel universe

a pineapple grove

a birthday cake for Snoop Dogg

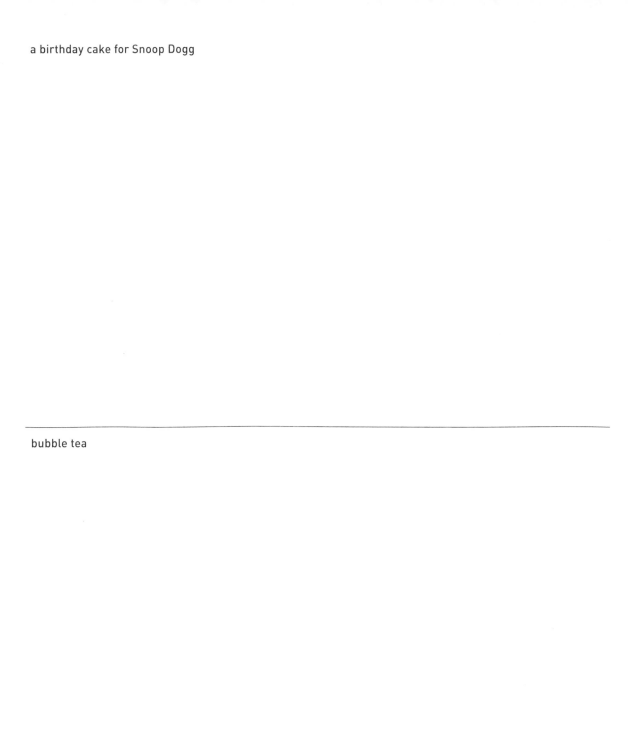

bubble tea

levitation shoes

.

a long nap

a slice of sunlight

a hydroponic garden

a robot dance party

a puppy pile

a swirl

a rooftop BBQ

déjà vu

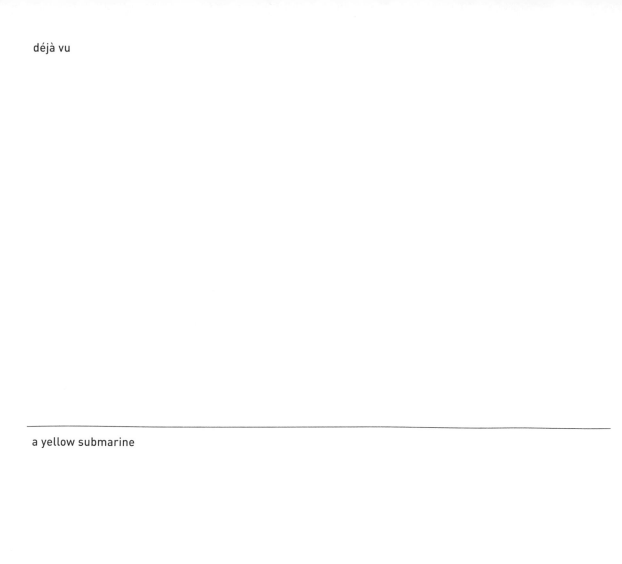

a yellow submarine

a THC molecule

a field of sunflowers

a movable feast

a glass marble

the Milky Way

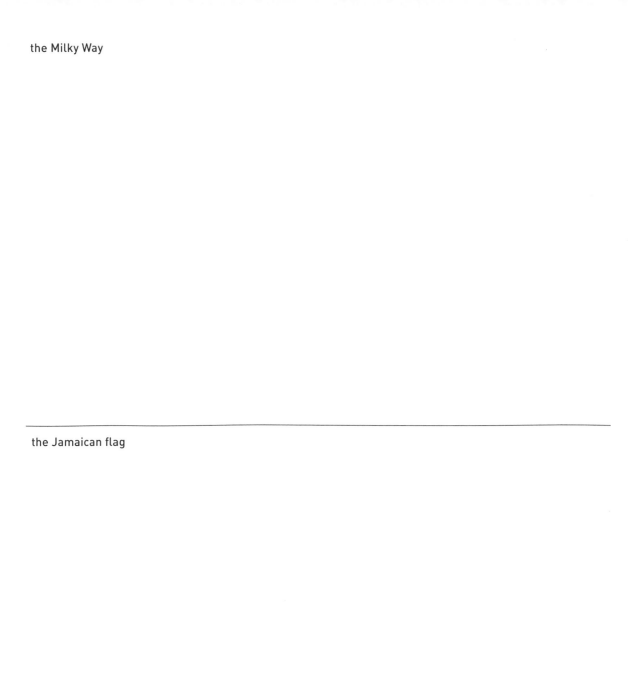

the Jamaican flag

a tray of freshly baked brownies

talk amongst your elves

a lounge full of llamas

soft rock

cookie crumbs

a non-bummer

a butterfly joint

the perfect wave

a natural high

inside your refrigerator

a flying kite

a skunk

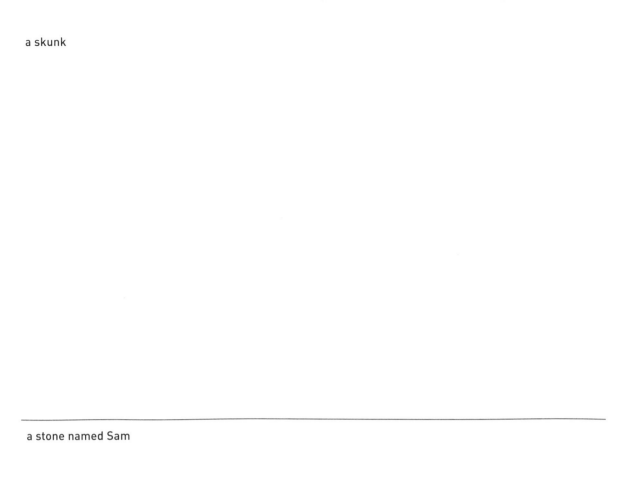

a stone named Sam

snailed it

an acorn

the world through green colored glasses

a mood ring

a bear hug

a happy houseplant

comfortable shoes

smoke signals

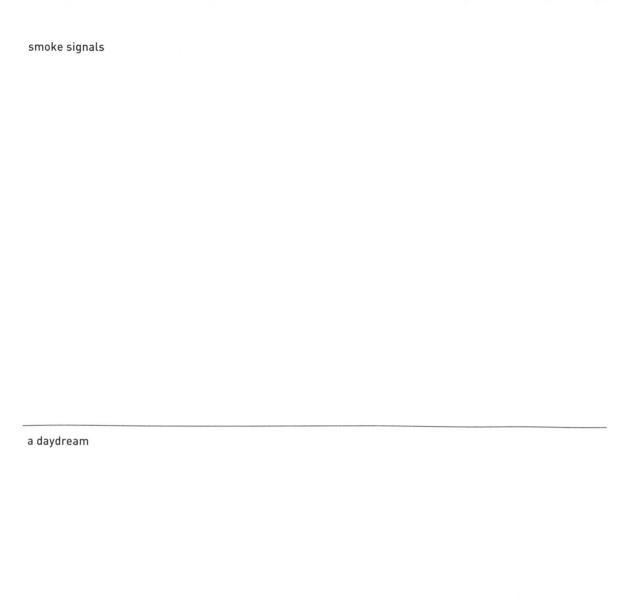

a daydream

the Big Lebowski's rug

a cat's purr

inside

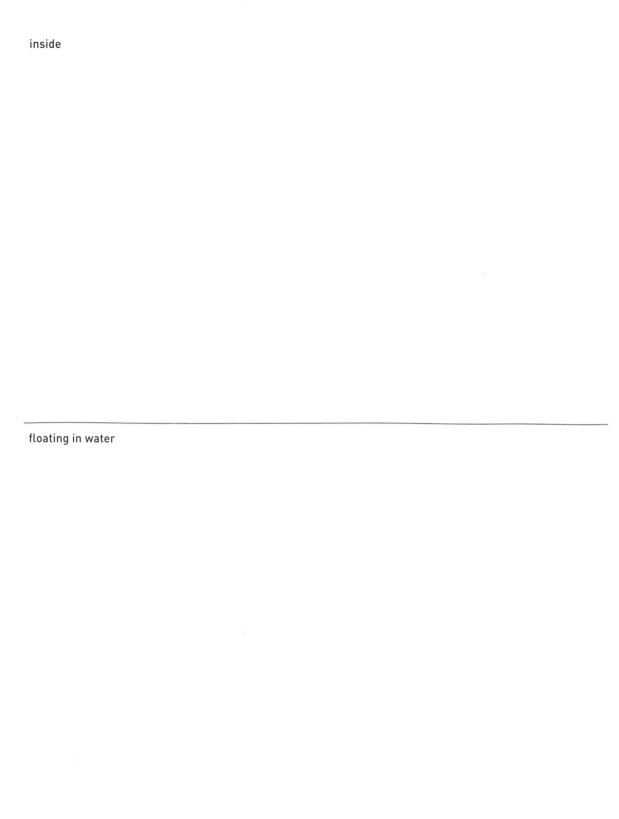

floating in water

dancing days

a bong lamp

mind over matter

a pipe organ

inhale

an egg

a dyed tie

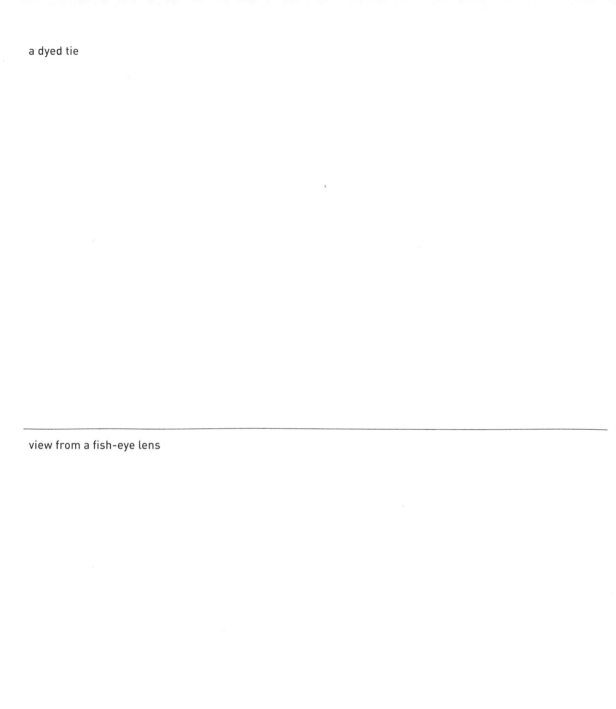

view from a fish-eye lens

a crystal ball

an hour glass

a statue on Easter Island

reflection of a reflection

a permanent vacation

a celebrity you'd like to get high with

bongos

an everything bagel

neon sunglasses

fresh laundry

the high life

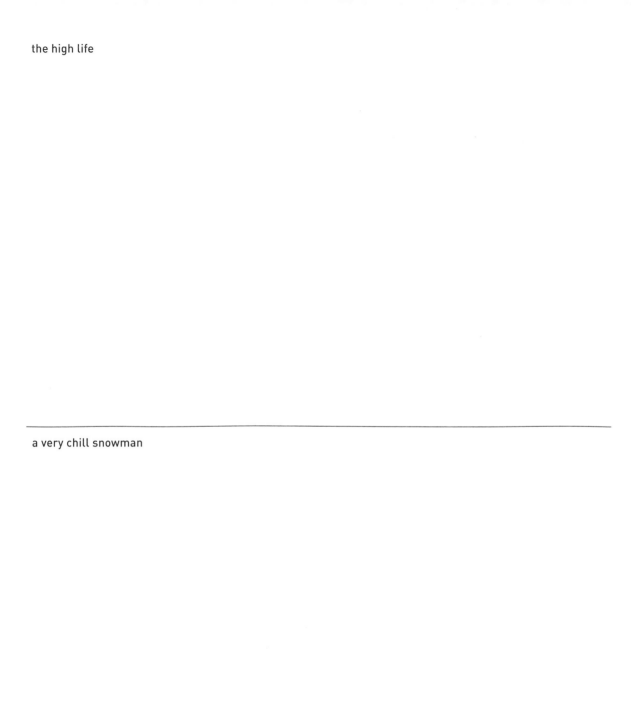

a very chill snowman

a hot box in the Arctic

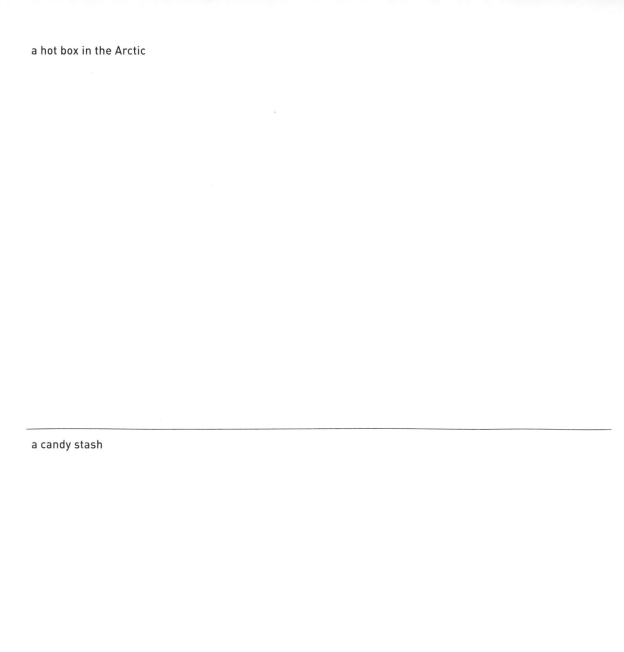

a candy stash

a Rocky Mountain high

your boss as a cartoon

your spirit donut

your glass half full

a vegetable hat

binge watching

twelve-sided dice

a hot tub in the woods

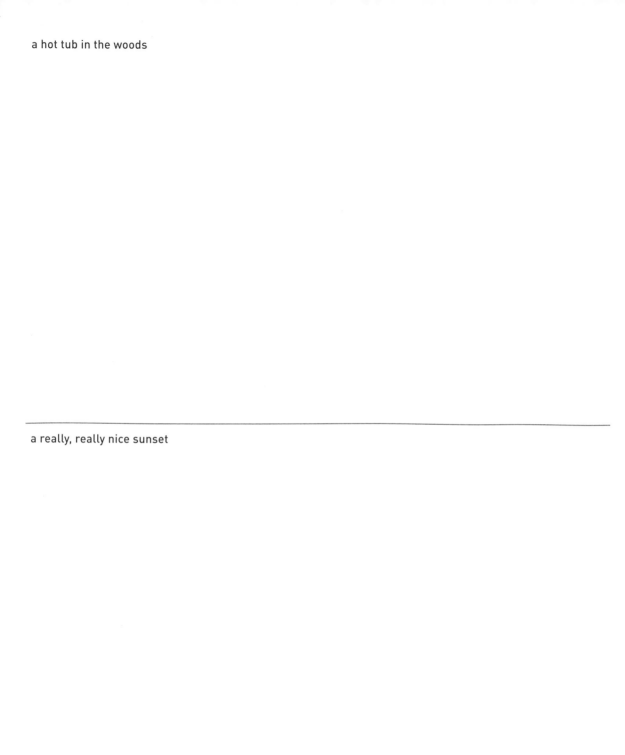

a really, really nice sunset

an award ribbon

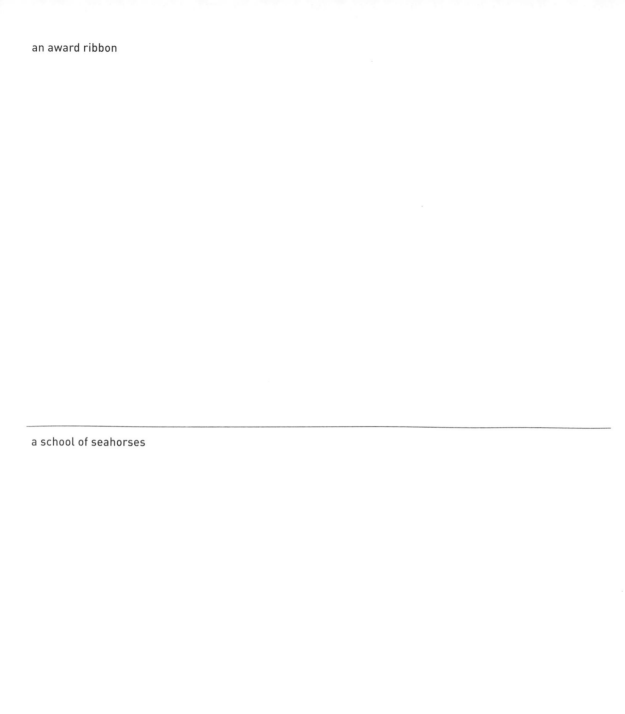

a school of seahorses

low gravity

loose ends

good karma

one unbroken line

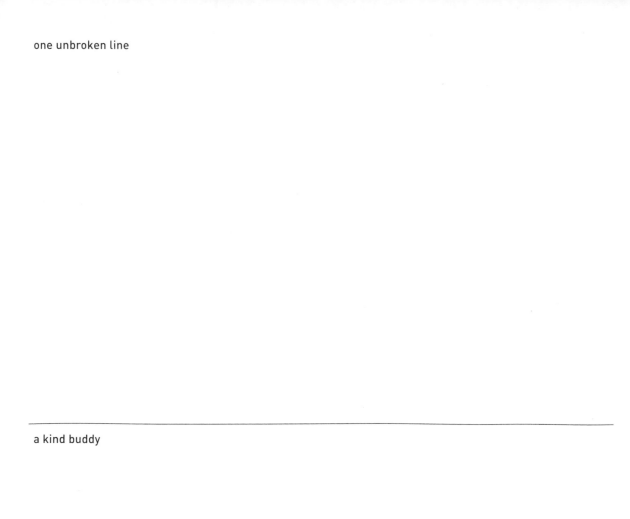

a kind buddy

a gradient

a silly symphony

deep thoughts

hash browns

an alpine horn

virtual reality line dancing

a chameleon in a T-shirt shop

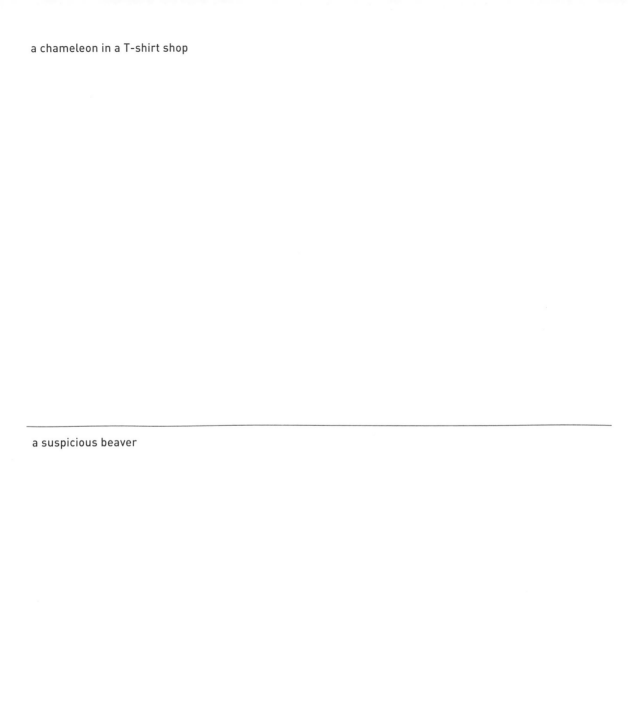

a suspicious beaver

a tiny squid

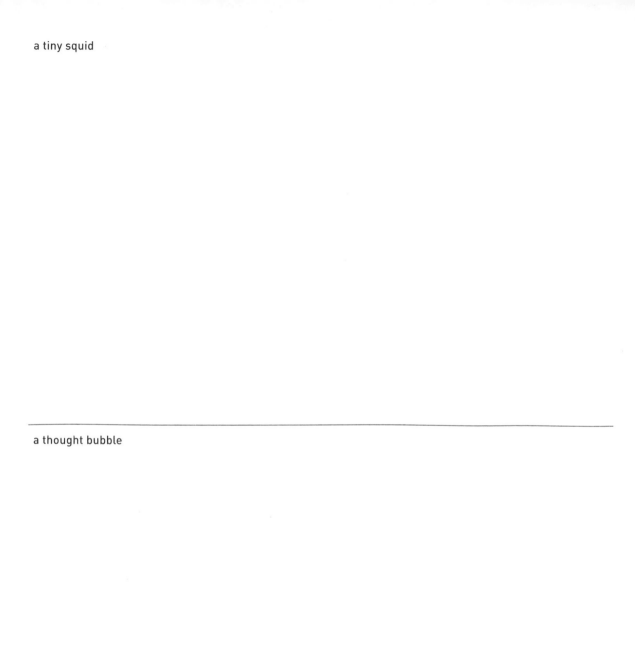

a thought bubble

refrigerator magnets

a disco tuxedo

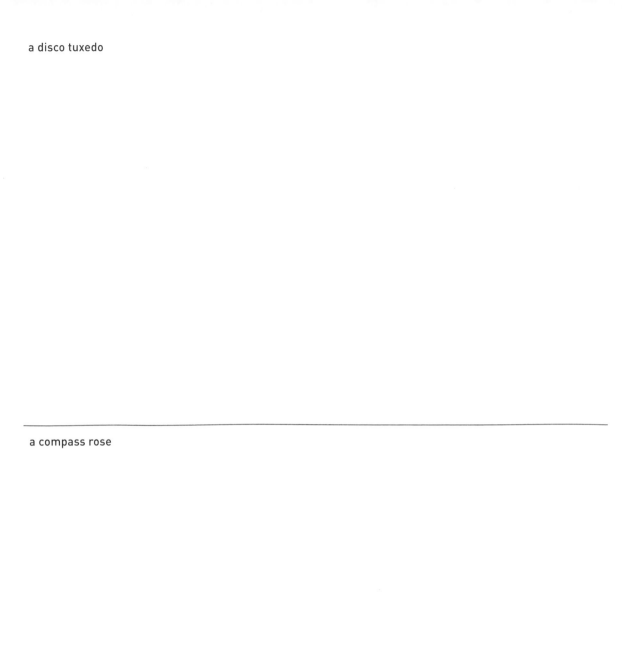

a compass rose

a double helix

a paisley swimsuit

decorative gourds

peanuts on parade

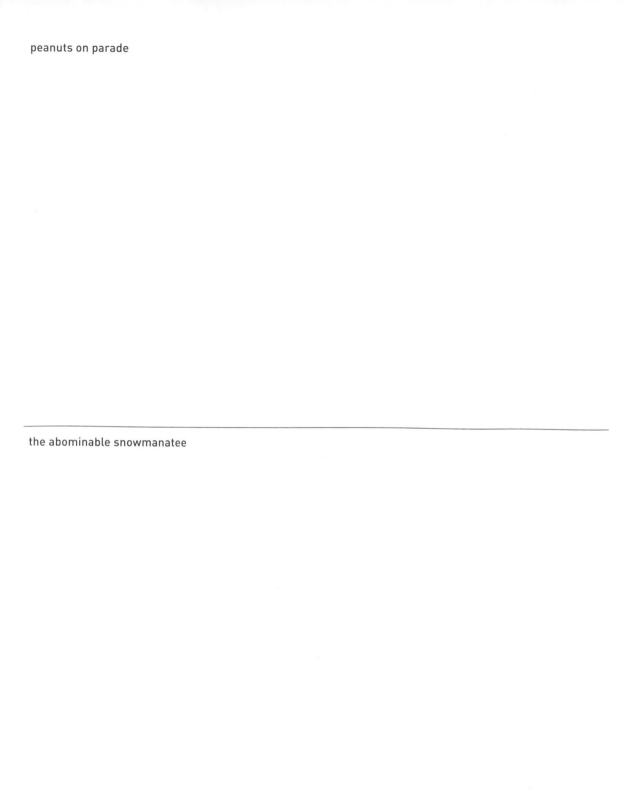

the abominable snowmanatee

a human bee-ing

a whipped cream headdress

pong

in the key of weed

fizzy water

a plastic lawn deer

an improbable sandwich

a conspiracy of corndogs

hanging loose

giraffe heaven

flying fish

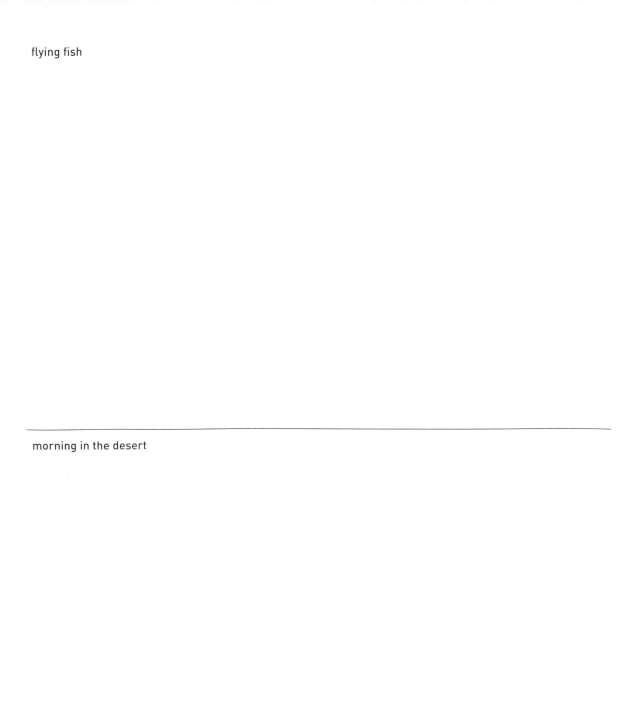

morning in the desert

rolling on the river

puff, puff, pass the ranch dressing

guitar strings

parallelogram-o-gram

a balloon baboon

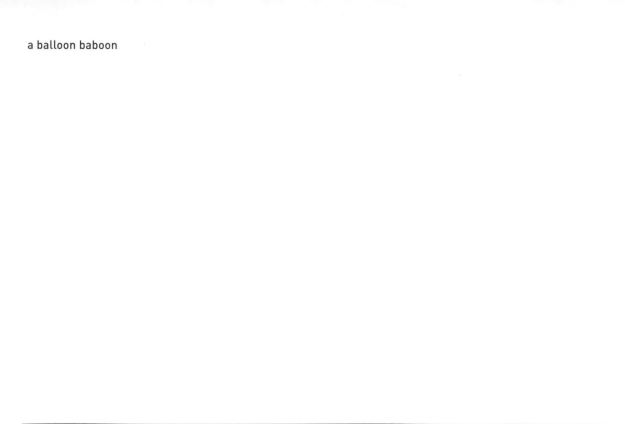

a freak flag

on a yacht

a panda in a hammock

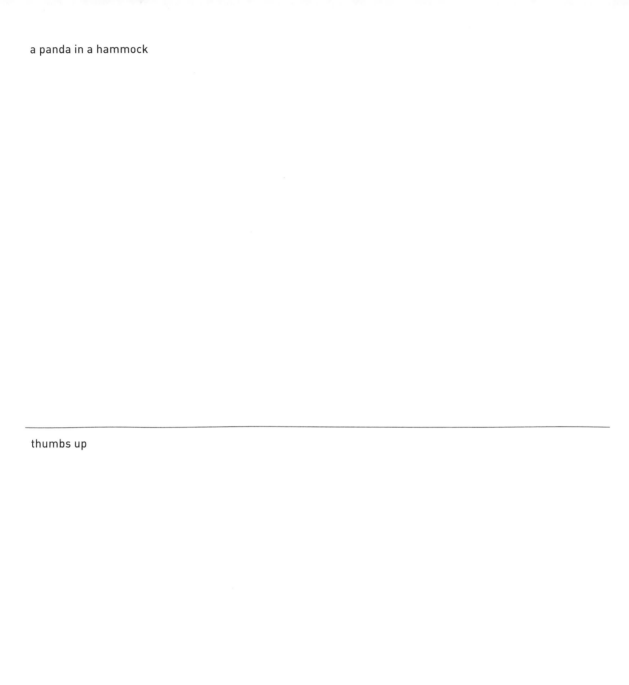

thumbs up

open arms

a Moebius strip

Japanese lanterns

a rubber band ball

up

a honey bear

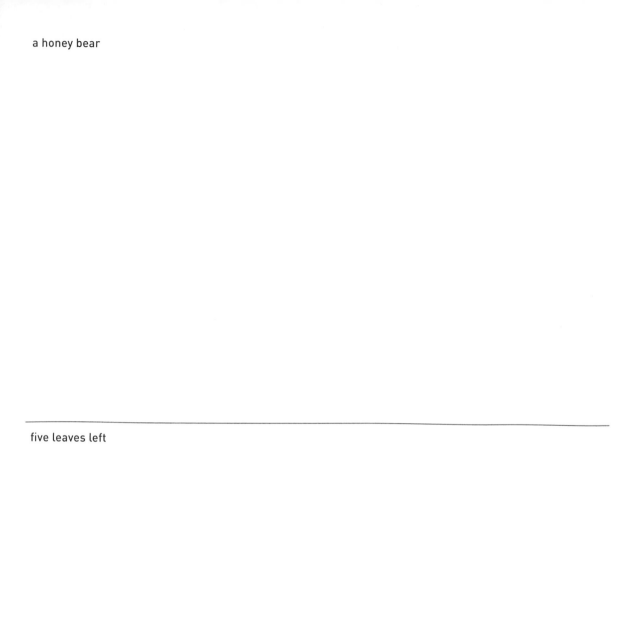

five leaves left

a giant baby

shrimp . . . surprise!

a multi-tool

a smooth transition

the texture of water

a hemp wedding dress

sleepy time tea

intersecting lines

a magic book

cereal milk

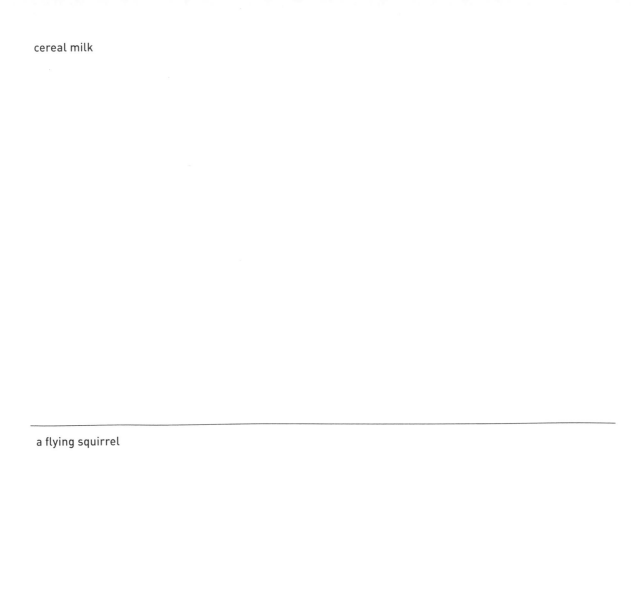

a flying squirrel

self-portrait with corn cob

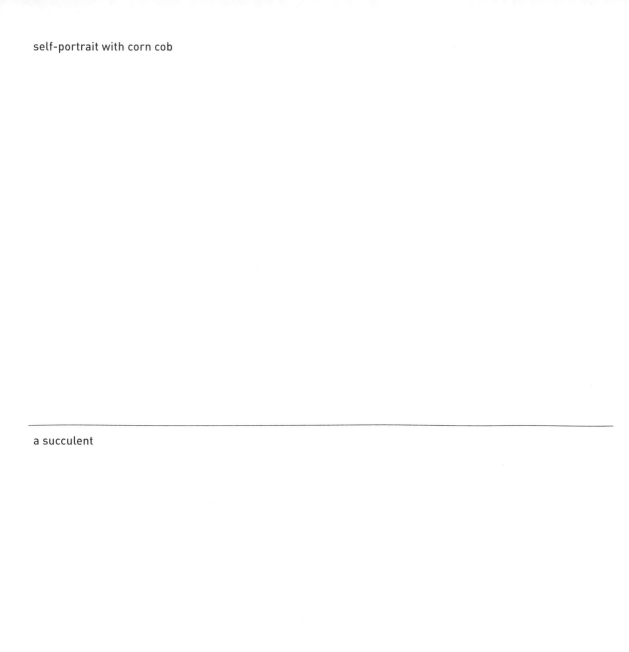

a succulent

one love

a nautilus

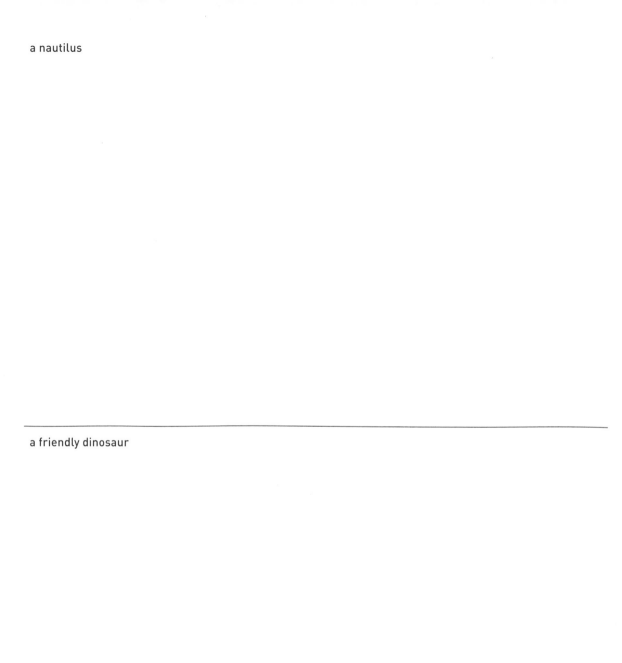

a friendly dinosaur

a six-mile smile

half-man, half-pizza

a geometric tattoo

a terrarium

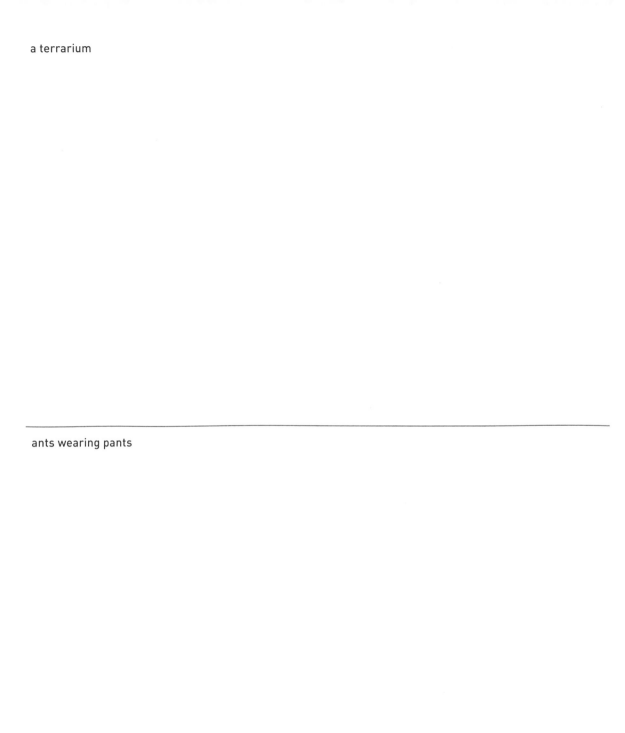

ants wearing pants

a field of tulips

inside your eyelids

a ship in a bottle

a doorway to infinity

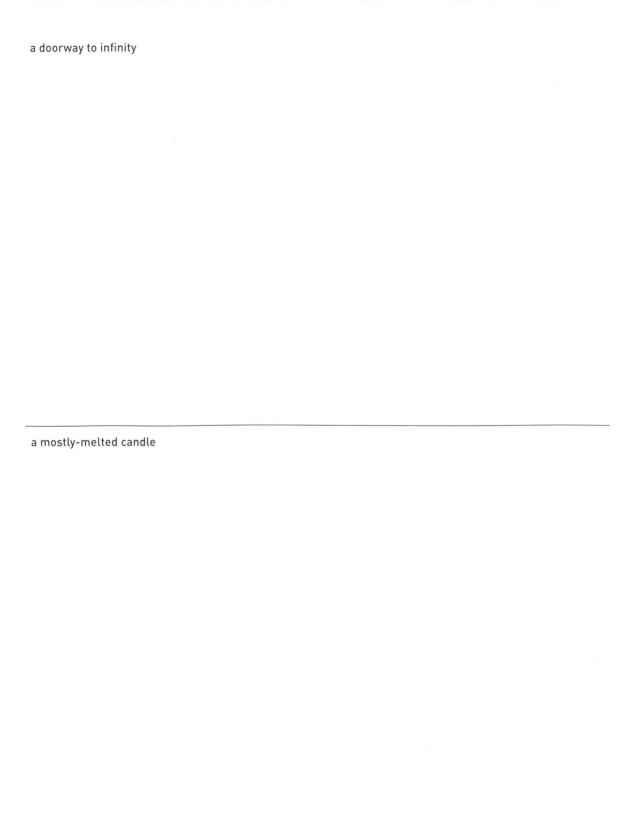

a mostly-melted candle

a scratch-and-sniff sticker

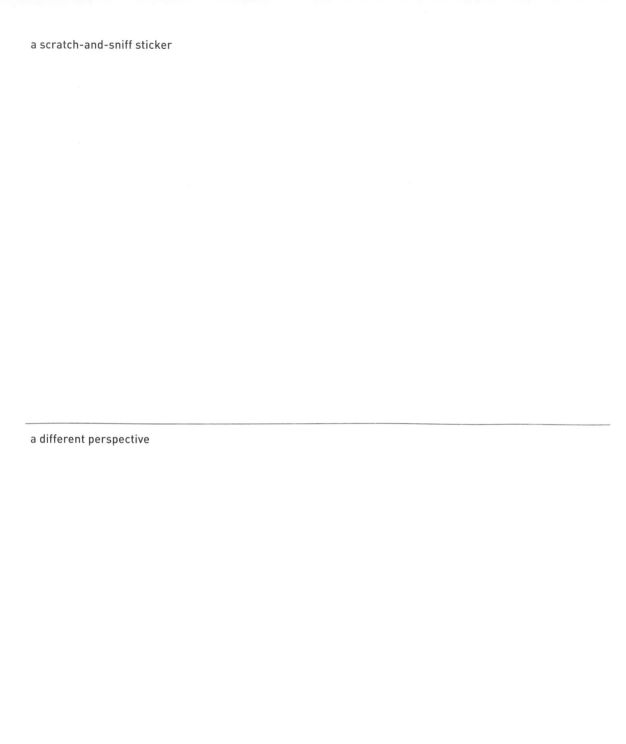

a different perspective

celestial vibrations

the future, one minute ago

paint drips

gratitude

a bouncy castle

a subtle disguise

wet and wild

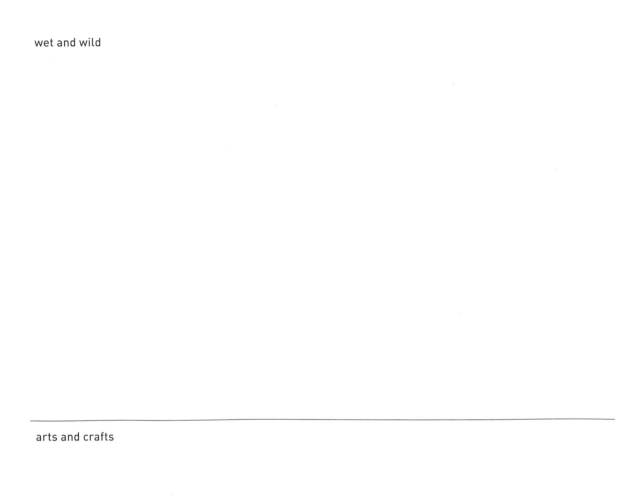

arts and crafts

a subliminal message

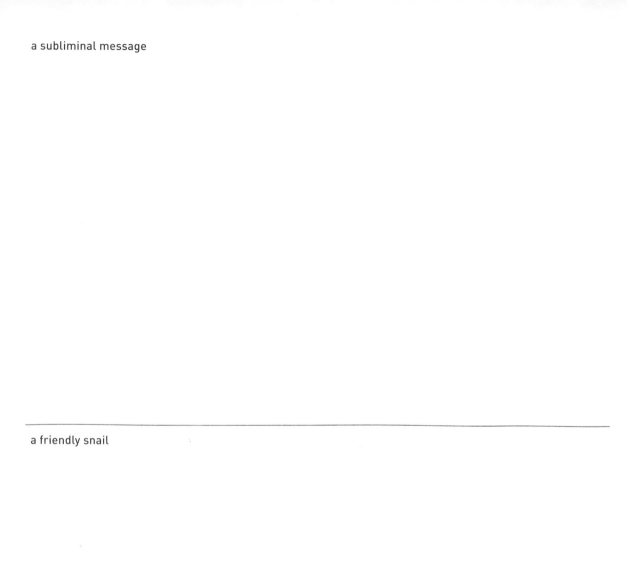

a friendly snail

a tree house

warm air

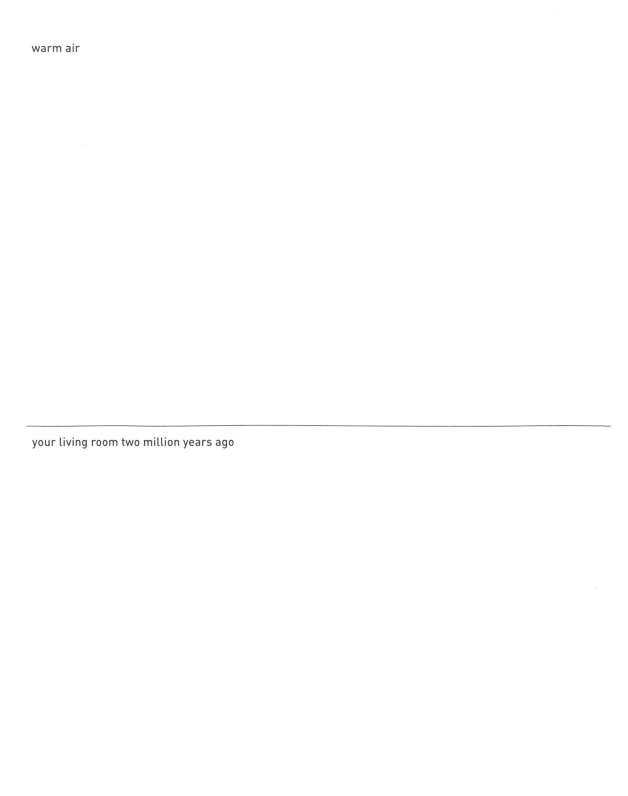

your living room two million years ago

a puppy licking your toes

cupcakes from heaven

an oracle

a staycation

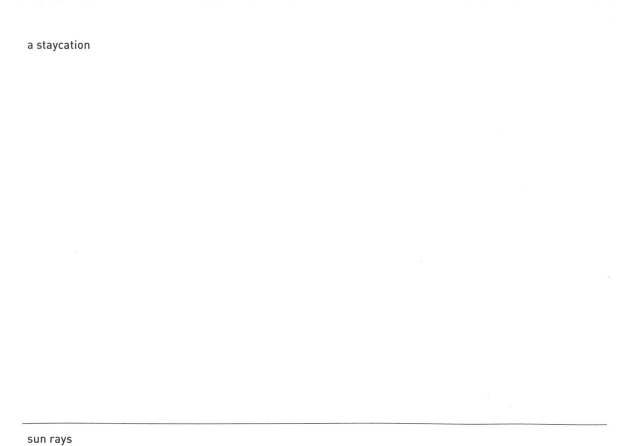

sun rays

bliss

inside a video game

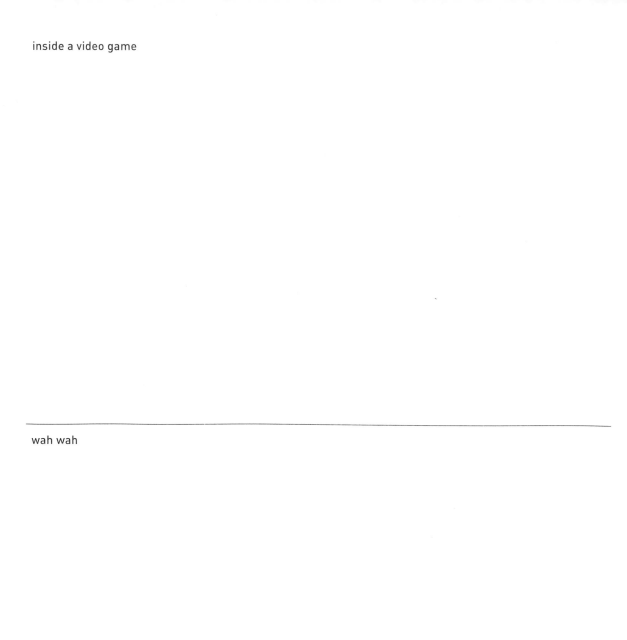

wah wah

curves

happy fruit

rain drops

a fern grove

a sumo wrestler doing a headstand

a koala's face

a stained glass window

a potted plant

a laser light show

these words

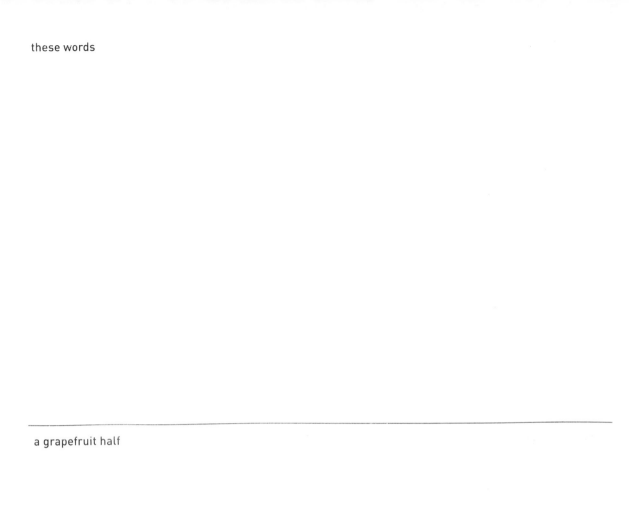

a grapefruit half

a hall of mirrors

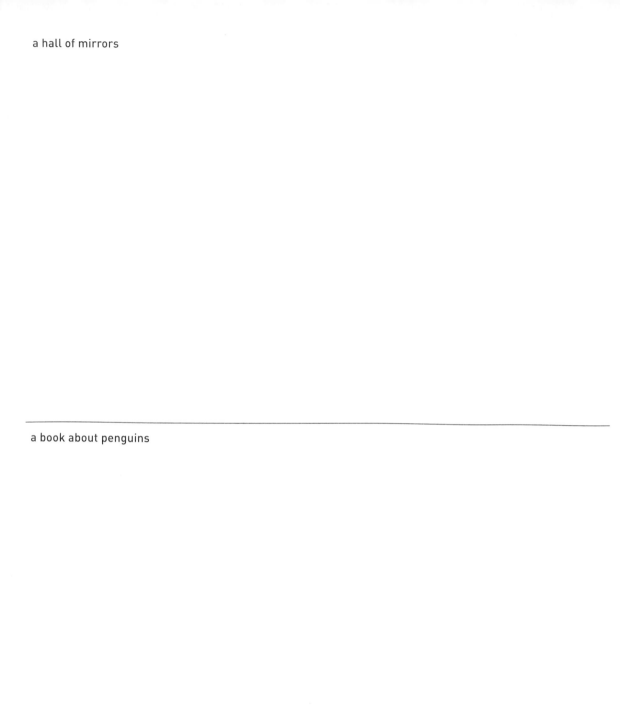

a book about penguins

a coffee stain that looks like a ballet dancer

a bed full of stuffed animals

your first-grade teacher singing karaoke

a watermelon seed necklace

a long beach

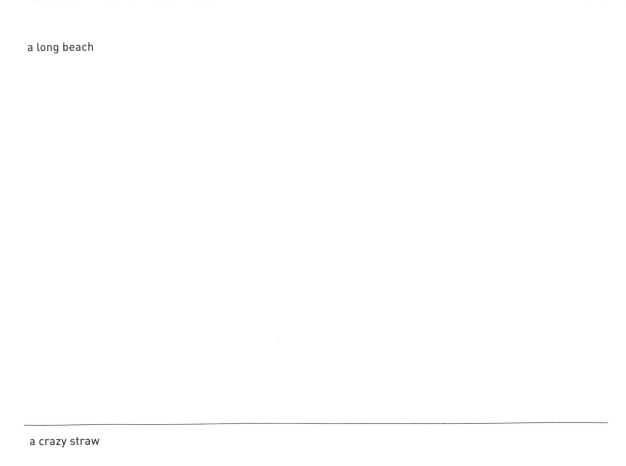

a crazy straw

bubble gum letters

squirrels doing stand-up

tropical fruit

a Canadian clown

a guy who really loves iguanas

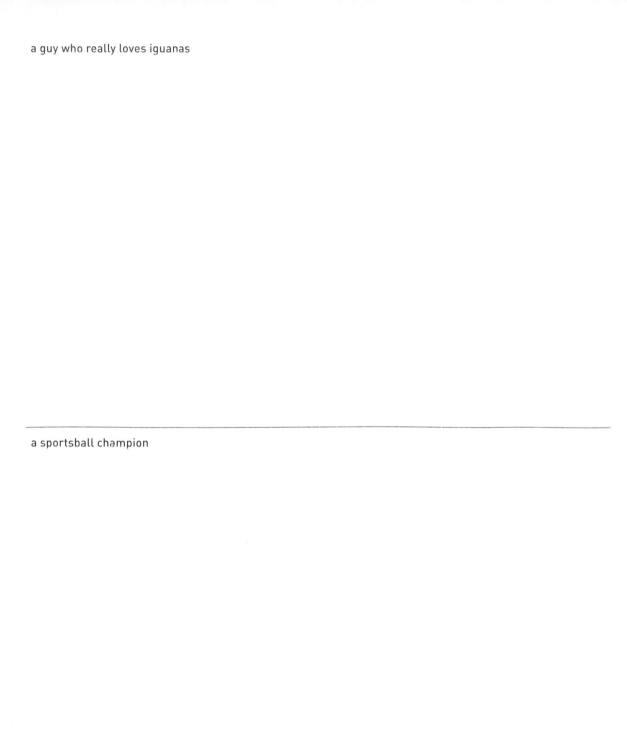

a sportsball champion

the meaning of like

a forty-two pointed star

big toes kissing

french fry art

lightning bugs communicating

record grooves

tree roots

a plate of spaghetti

a spice rack

a family of bananas

a glowing tambourine

a button collection

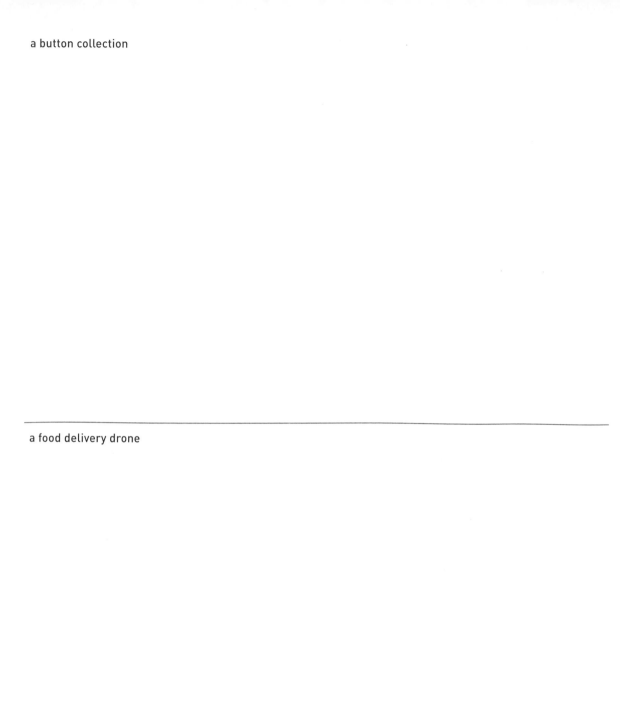

a food delivery drone

a cheese piñata

ice cream sprinkles

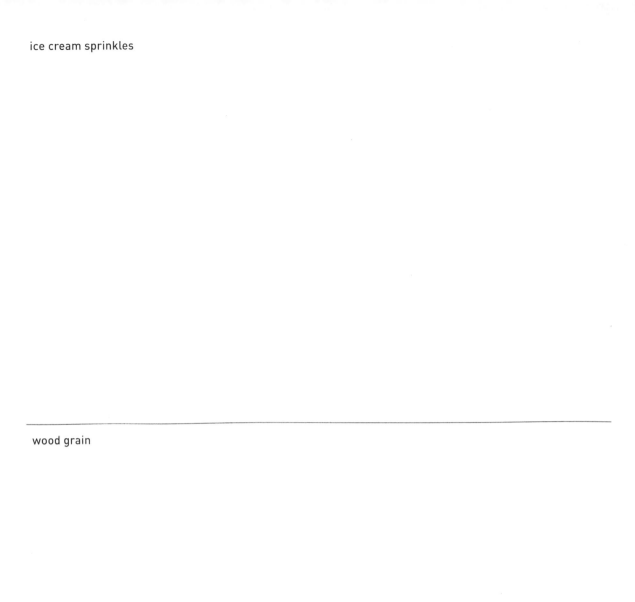

wood grain

a blooming cactus

curling vines

an eclipse

one serious roller-coaster

a full pocket

an apple peel

train tracks

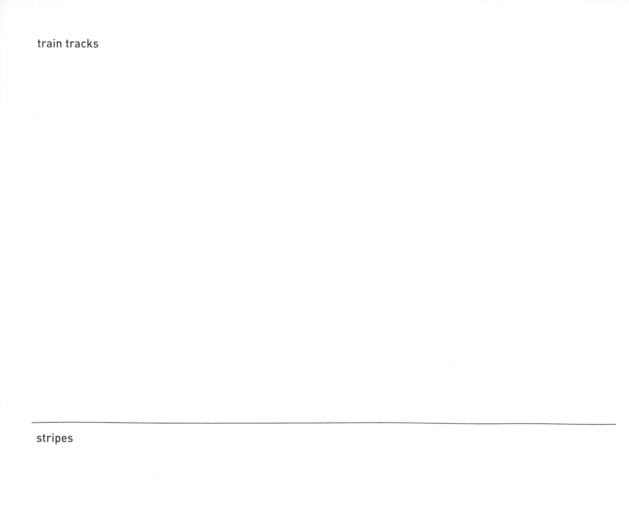

stripes

a foggy window

lucky socks

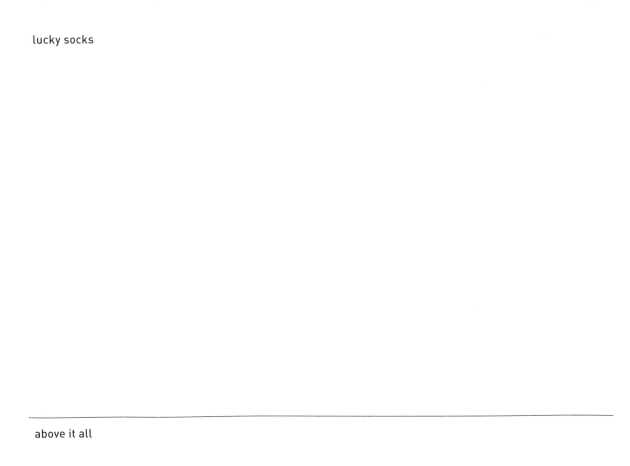

above it all

holiday lights

a honeycomb

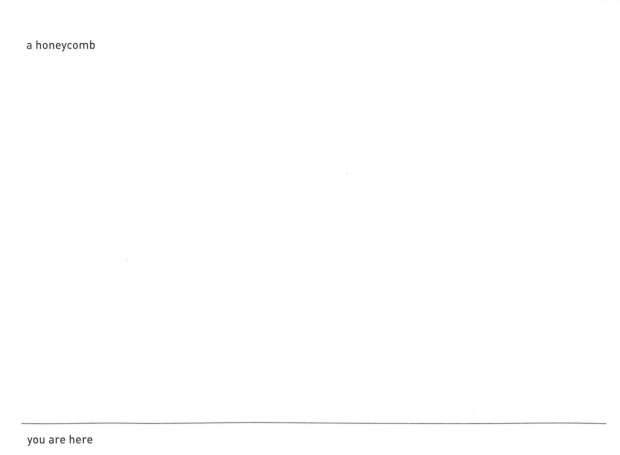

you are here

all signs point to yes

arm hairs

triangles and circles

a finger painting

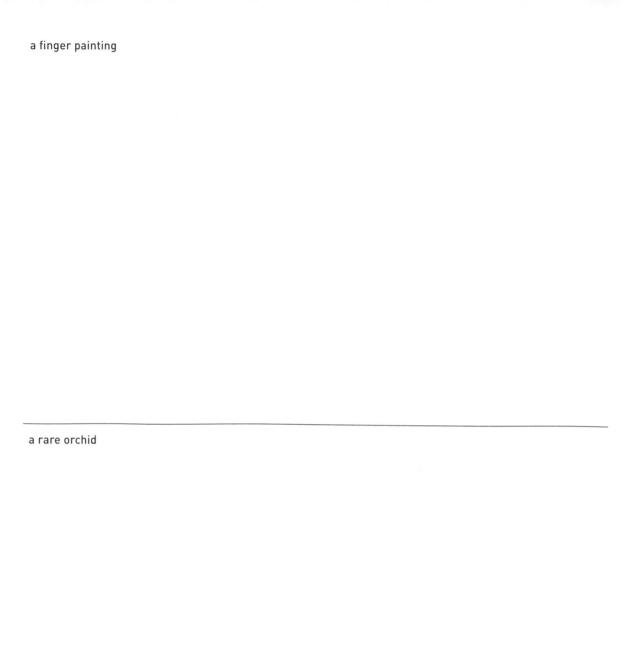

a rare orchid

a cinnamon roll

a swan boat

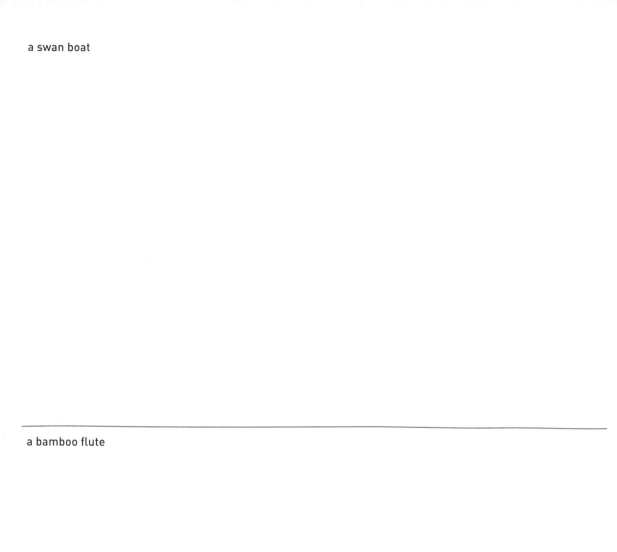

a bamboo flute

hedgehog house slippers

a marshmallow treat castle

an inflatable pool

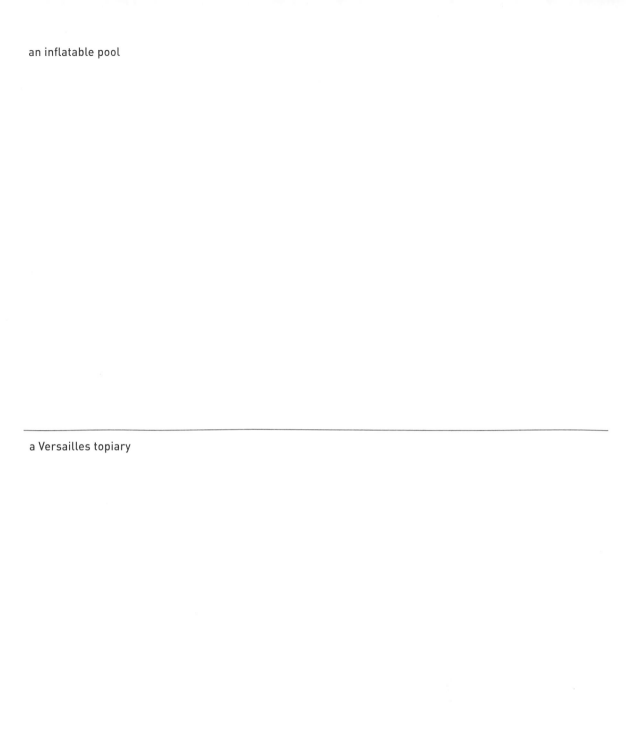

a Versailles topiary

a three-story hookah

an unidentified feather

a commemorative legalization postage stamp

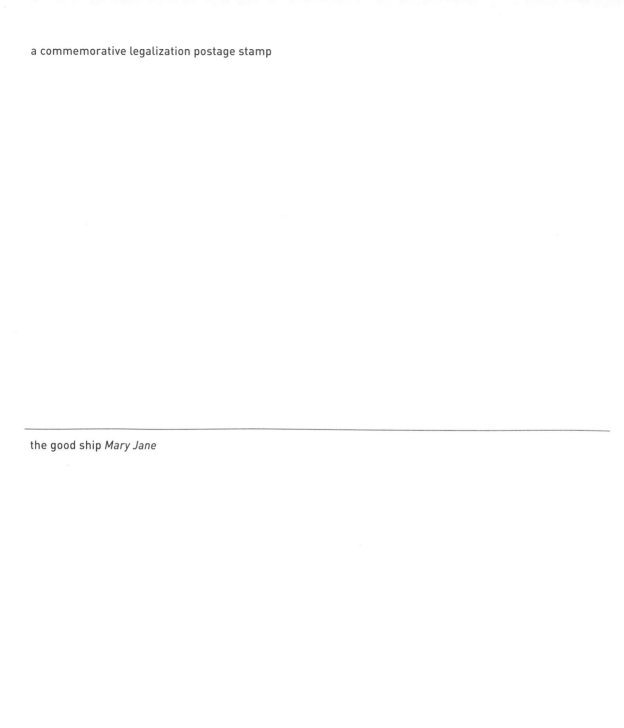

the good ship *Mary Jane*

all-you-can-eat pancakes

a starfish

floating in space

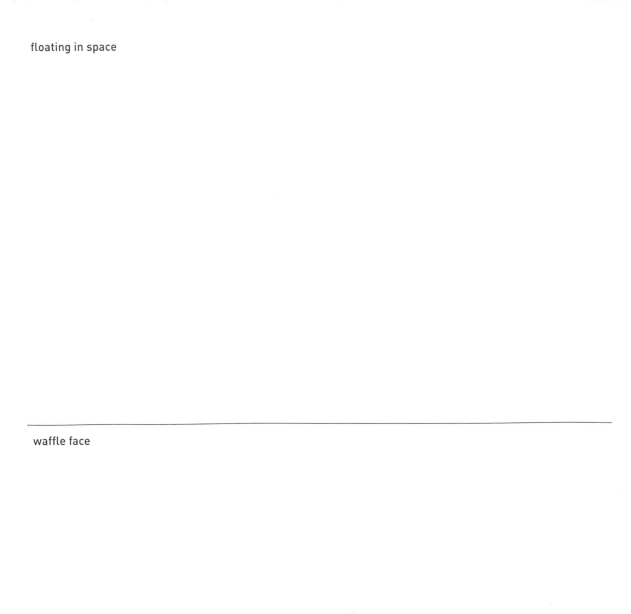

waffle face

flying over the Grand Canyon

a Halloweed costume

a mystery spot

a silent film

arrowheads

a hand-thrown pot

topographic oceans

an ancient redwood

a flock of seagulls

a brain emoji

a stonewashed jean jacket

jasmine tea leaves

surround sound

opposite day

wobbly shapes

a giant

a diagram of a clock

a wool cap

horsing around

a farmer's tan

organic butter

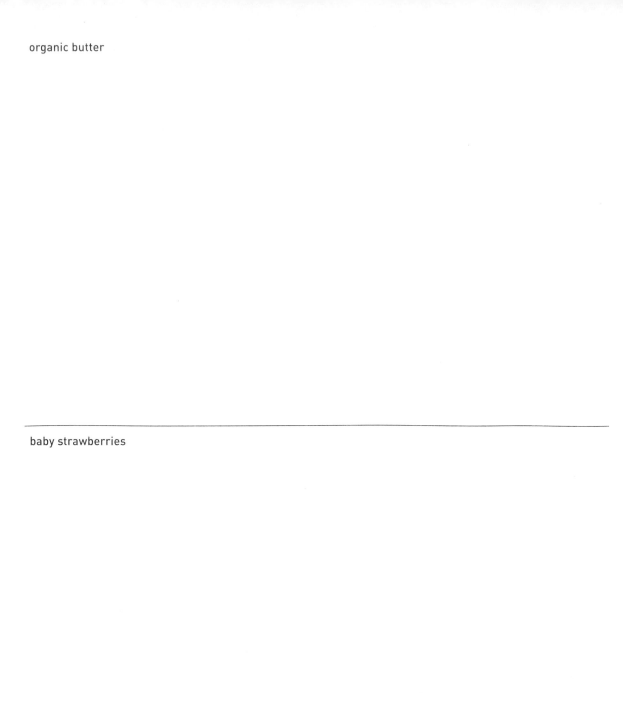

baby strawberries

a 1980s mannequin

bikes spokes

paw prints

physical graffiti

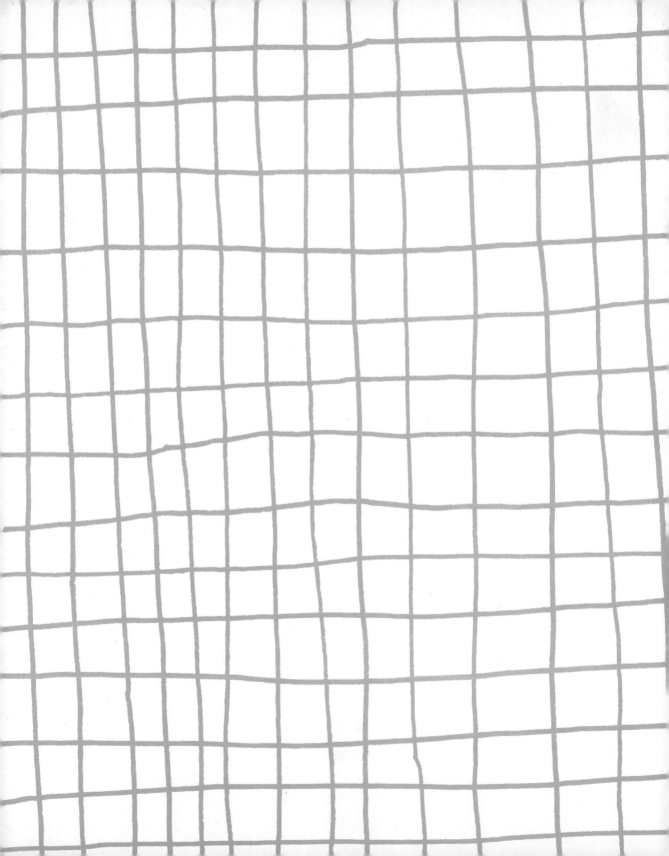